Forty-Five

Also by Frieda Hughes

Poetry

Wooroloo

Stonepicker

Waxworks

Children's Books

Getting Rid of Aunt Edna

The Meal a Mile Long

Waldorf and the Sleeping Granny

The Thing in the Sink

The Tall Story

Rent a Friend

Three Scary Stories

Forty-Five

Poems

FRIEDA HUGHES

HarperCollins*Publishers*

HarperCollins books may be purchased for educational, business, or sales promotional use. For information, please write: Special Markets Department, HarperCollins Publishers, 10 East 53rd Street, New York, NY 10022.

FIRST EDITION

Designed by Kara Strubel

Library of Congress Cataloging-in-Publication Data
 Hughes, Frieda.
 Forty-five : poems / by Frieda Hughes
 p. cm.
 ISBN-10: 0-06-113601-8
 ISBN-13: 978-0-06-113601-6
 I. Title. II. Title: 45.
 PR6058.U347F67 2006
 821'.914—dc22 2006043527

06 07 08 09 10 ID/RRD 10 9 8 7 6 5 4 3 2 1

To my husband, László, with love.

CONTENTS

FOREWORD

When your life—and your parental heritage—is the subject of lifelong speculation and intrusion, it is harder to tell your story than it would be for most of us. When you are the daughter of Sylvia Plath and Ted Hughes, your past and your parents get stolen from you on a regular basis and reworked according to a dozen different dialectics: gossipy, ideological, literary, romanticized, quarrelsome. When I first met Frieda Hughes over a decade ago, I found it impossible not to blurt out that she was the baby in my favourite poem of childbirth, beginning, "Love set you going like a fat gold watch . . ."

But then at least I remembered the last words of that poem, acknowledging that every baby comes individual into the world, "a clean slate, with your own face on." Over the years since then I got to know Frieda, and see that, indeed, her voice and talent are individual, idiosyncratic, and nobody's but her own.

Now, in typically headlong and original fashion, she has chosen to tell the story of her first forty-five years: from the sadness overshadowing her early childhood, through marriages and betrayals and mistakes, to the high plateau of her partnership with another remarkable painter, László Lukacs. This is not a plodding autobiography, but the internal story, the utterly subjective way in which—if we are truthful—we all remember our own lives. The poems are a string of glittering or alarming moments, a necklace of life. They are, quite simply, the way it felt to her at each time.

There is fear here, and desertion, confusion, infant rage,

and adolescent misery; there are also joy and understanding and boundless, raging energy. Ideally, anybody reading them should also turn to find reproductions of the forty-five abstract paintings which run alongside each year, a 225-foot-long artwork of breathtaking vigour and awkward size whose final home is still uncertain.

It is an original way to record your life, this partnership of short lyrics and large canvases—but then, it has been an original life. We are privileged to share it.

Libby Purves, May 5, 2006

INTRODUCTION

On my fortieth birthday, April 1, 2000, I wanted to celebrate what was a significant date for me. Being a poet and a painter, I thought of writing a poem and painting a picture for each year of my life, from birthday to birthday—the paintings to express the emotions that coloured each year and the poems to provide the actual subject matter which provoked those emotions.

I had been trying to break free from the constraints of figurative painting in order to better express my emotional reaction to my subjects, and these paintings, being emotionally based, could only be abstract.

From conception to completion the project took five years, so I added five paintings and poems to bring it up to date as, by my forty-fifth birthday, my life had reached a happy plateau and a good place to end my project.

The outcome was the poem sequence in this volume and an abstract landscape of my life, four feet high and two hundred and twenty-five feet long on forty-five canvases.

In writing the poems, I concentrated on the events and incidents—however big or small—that affected me most. What developed were snapshots of the difficult times in my life, because they had the most profound effect on me, requiring my effort, my energy, and my full attention, while dragging my emotions through the mental equivalent of a gorse bush.

There were happy times, but happiness was not what chiselled a shape out of me, and often it flowered in a garden of broken glass from more painful experiences. There was also

peace, but it was generally stolen from other more taxing situations. Nor did humour shape me, although I adopted it as a coping mechanism.

So these poems by no means form an autobiography, but are concerned with the more challenging moments in my life, and my resolution to do the best I could in meeting those challenges.

The incidents I have described are in the moment; they do not define my whole existence and should be taken in the larger context of my life, which is perpetually evolving and in which I feel to have been very lucky in so many ways.

Relationships mentioned here are also not set in stone, except in their historical sense, and from only my point of view and my feelings at the time. Outside that, they too are constantly changing.

Each person's experience of a life widely differs; this is my experience of my own life.

While the paintings do not accompany this text, they may be viewed on:

www.friedahughes.com.

Forty-Five

FIRST YEAR 1960

When I was born
There were several things about me
That were true,
But I didn't know them yet.
I breathed,
I was held lovingly,
I was so completely new
I'd nothing to forget.
I explored
My ground-bound world with curiosity,
Blotting paper blank as parchment
Where nothing's written yet.

SECOND YEAR 1961

London was going to make way for Devon
In September. I wouldn't have known.
Familiar faces, smells and sounds
Cradled me to my new home.

Towering nettles and raspberry bushes,
Butterflies with wings like eyes,
Cabbage white caterpillars
And the three elms that filled the sky

From atop the Roman mound
Marked out my boundaries.
I crawled with woodlice, voles and centipedes
Among the fallen apples and the lilac trees.

Mice and hedgehogs,
Rabbits, frogs and blackbirds
Welcomed me as a stump among them,
Taking root and learning my first words.

THIRD YEAR 1962

My thoughts were complicated,
Too hard to describe by the frustrated
Tongue in my mouth, too weak
And tangled in syllables to allow me speak.

I wanted to grow faster still,
Improve upon my verbal skill
And ask the questions plaguing me
To define clear boundaries of safety.

Some things were given—company,
A brother who would play with me.
Some things were taken—a father told to go,
The home I'd grown to know,

And at the loss my memory
Crawled into a black hole for safety.
Where before each tiny thing I saw
Imprinted, I remembered nothing any more.

My mother, head in oven, died,
And me, already dead inside,
I was an empty tin
Where nothing rattled in.

FOURTH YEAR 1963

There were shapes, sometimes complex,
Minor incidents that had been
Remembered out of context.

Relatives emerged from the places
Through which I travelled,
Wilfully numb. Their faces

Replaced each other as if they were
Different heads of the one body,
The hydra

Nursing her young.
Mostly, it was black. Waiting
To live again hung

In the back of my mind,
Consciousness, the held breath,
Remained blind.

FIFTH YEAR 1964

I crawled from the darkness
In the back of the car, new again.
I tried to remember stepping into it.
I tried to remember daylight.
I tried to remember anyone I knew
But I'd been wiped clean, everything
I'd ever been—obliterated.

All night, at journey's end, I expected
My parents to fetch me
From among these strangers.
Their faces escaped me, but I thought
I'd know them instantly.

None came. While I waited
I struggled for my name;
It wasn't there in my mind,
On the tip of my tongue,
Or anywhere in a crevice
In my skull. Day by day
I pieced myself together and believed
I'd been borrowed—adopted even, convinced
That this, my first new memory,
Was the threshold where unconscious child
Became sentient being, implanted like a tooth,

But lost, not found,
In the mouth of this new family.

The boy became my brother,
The troubled man, my father,
And the woman I imagined was my mother
Became my aunt,
Who'd given up her life in France
To look after the strange animals
That children are.

I collected these facts with care,
Committing them to the empty room
In my head, adding to them there.
But, in putting back
My missing pieces, one by one,
I could not undo
My doubt that I belonged.

SIXTH YEAR 1965

Books were more than walls
Of rooms in houses built across the bedroom floor,
Their pages opened up the door
Beyond days at school and playground calls

Of friends with happier tomorrows
And both parents still alive,
While only one of mine survived;
My father, bag of sorrow.

I read of palaces for kings
And streams with talking fishes
Granting people's wishes
For all their happy endings

Yet to come. I wanted one for me,
Time again I'd build a home
Of books or blankets, wanting stone
Or wood or bricks, a place to be

Where I could stay,
But no sooner was each wall
Familiar, we'd pack the car and haul
Ourselves away.

In January we arrived
In Ireland, my father searching for a new
And different life to take us to,
Now our family of three
 Was sometimes five.

SEVENTH YEAR 1966

Ireland had fish in it, and crabs
In the stream where we dug peat
For the fire. Icy water—so cold to touch
It was as if my fingers crushed—
Split apart the moor a footstep wide,
Clear as molten glass,
I'd cross it in a stride. In school
Mother Mary's effigy listened to my
Irish vowel sounds and nouns
From atop the stationery cupboard.
Green and fecund woodland
Fostered me, where trout at the riverside
Cooked, their pink flesh steaming.

Water, pumped in by hand
And heated on a stove,
Was replaced in a move
By plumbing and a beach of boulders
Heaped with ropes of seaweed
That undulated on the tide,
Intestinal green bloating floaters
Blistering the skin of fingers
That reached for the shoreline,
The chill and salt slap of exhaling sky
Exhilarating.

Devon was warmer then, the hands of the aged
Welcoming me home again. But I remained hidden,
Somehow invisible in the wind's turmoil,
Watching father and son tying flies
And mother and daughter sticking paper
Feathers to wings for angels,
With my gooseberry eyes.

EIGHTH YEAR 1967

I sharpened knives and skinned
A roadkill badger, proud to see
Its hide left stretched and curing
In the barn of owls and bats.
I worked with clay and Plasticine,
My blue flowers became legendary,
My dragons pink and green.

Strangers came and went, I'd catch
Men embracing book-stacks
Leaving. I started bolting doors
And closing open windows
On the ground floor,
But nothing I did
Could keep out the thieves.
"We're friends" they said, and me
So small beside them, a too-late thumb
In the dam's chasm, through which
Everything around me leaked,
Friends, dogs, objects and relatives.

The knife I'd sharpened
In the kitchen drawer
Could take me away
One day if I wanted,

And tonsils out for Christmas and ice cream
Meant I'd no earaches anymore.

Sensitive to every pull and undulation
Of the quag on which I stood,
Accustomed to uncertainty and speculation
I kept my council, feet in mud,
Ordering the chaos inside my head
From what I saw and read,
To plot a nightly course across
The bog of crocodiles
Between my bedroom door and bed.

NINTH YEAR 1968

In my funny-looking American clothes
Sent over for Christmas and
Too early for Devon, I curled self-consciously.
We were already poor in the butcher's eyes, he knew
We'd dripping on bread for tea.

My father taught me trees,
And clouds and birds and animals,
I brought wild creatures home with me,
Broken winged or hit by car,
To mend them. Some lived, some died,
The little souls inside too fugitive
For my desperate fingers feeding them
Pipettes of milk and fresh flies.

Between school and a wish to be invisible
And home and a wish to be seen,
I made my first dress as square as a sack
On a borrowed sewing machine,
Its yellow gingham seams unfinished
When the machine was taken back,
But the love of making clothes,
Curtains, cushions, bedspreads, anything,
Never left me.

A toybox at Christmas
Overwhelmed me with generosity, I believed
It meant love from the giver I loved
And would have kept for myself as a mother,
A gift to me. I imagined all the things
I might eventually find to fill it.
I gazed in awe at its emptiness,
And my name
Painted on its door, it opened
The New Year, bright and shiny with hope
And white gloss.
I waited, breath bated, to see
If the mother was meant for me.

TENTH YEAR 1969

My first ghost wore a black and white
Flowered miniskirt and tight
White sweater. I touched her cold air
As she walked through the wall in the hall
Instead of using the door.

I saw visions of my time to come,
Episodes of my future life
As memories in my head
Where the past ones should be.
I saw my husband, my mate,
The right one at last,
Walking towards me
On a garden path,
But no amount of focus
Would disclose his identity,
Or how long I'd have to wait.

I outgrew the village school
As my grandmother outgrew life,
My shells clattering on the door to her coffin
At her funeral, so loud
I cringed in shame
At pointing myself out, weeping.

The only coins I ever stole
Came from my father's pocket,
To buy a fox fur and mantilla lace
As gifts from him
To dress the gaps and cracks
Made by argument
In the shoulders of the woman
From whom I wanted mother-love.

The delicacy of stamps, the intricacy
Of seals in wax, the immediacy
Of a round pebble in the road,
Unnaturally spherical,
Were my treasure trove,
And all the time I longed
To fill the void in family
Between father, aunt and brother.

ELEVENTH YEAR 1970

All my wishes came true,
I just wasn't a witness at the wedding.
But with love came corners,
And angles, and unspoken meanings
Without resolution since no maps existed
To find the solution. I was seeking my way in the dark.
But the emotional maze I found myself in
Echoed with messages and clues
Not meant for me.

I had nightmares in the city,
Ninety in a camera's click
Skipping eighty years,
My life over already,
My face unrecognised
By my family.

In Yorkshire, between the barking geese
On the spine of the hill's back
And school visits to the swimming pool,
I moulded shells from molten lead over bonfires,
Collected acorns amongst the bracken
To plant forests, discovered gerbils
Can eat their way out of anything not metal,
And guinea pigs breed like rabbits.

Then Lumb Bank burned
While I was loosing spinners in Loch Ness,
Collecting ticks from an adopted dog, with my father,
My brother and my new mother,
In a mildewed tent at the lake's edge.
The arsonist took only one thing—the box of tin
In which I kept my treasures
And my christening things.

When the girl came up to me
And showed me how a silver fly
Grasped its stud of bone,
I recognised it as the one
My father gave me. She even had
My missing silver mug with teddy bear,
And Granny's pearly beads as square
As tea caddies. I knew then
The woman who had broken in
To set fire to our home
And take my box of tin.

TWELFTH YEAR 1971

Collecting stamps
From my father in France
I was at boarding school,
Where near-death on penicillin
Was disguised by matron as my wicked lie,
When she gave me another child's medicine.
Three days unconscious, my throat so dry
I was speechless for the water
The doctor dribbled into me,
His voice a hammer on the anvil
Of her stupidity.

Persia, sand and stone,
And palaces succumbing to neglect
And wild roses, had released its women
From purdah. Amber and turquoises eschewed
For striped socks and platform shoes, they were
Learning TV. The desert seeped into me
Like a stain, the cornelians, the cinnamon,
Nutmeg and spice, the man's body,
Hands chopped off at wrists,
Mouth open, tongue-slit and earless,
Left sodden in the gutter with
Three-foot blocks of hotel ice,
Where old men pissed.

Actors were my family; my aunts
And uncles, trekking desert villages
With improvised performances, greeted
By impoverished locals in their finery; painted dolls
Against the desert gravel, white as bone.
I killed cockroaches, ate yoghurt and pistachio,
And watched *Orghast* beneath a ball of fire,
My father imprisoning his Prometheus
In chains, recognising chains,
And a sacred cow
Led across a frozen sunrise.
I sat in cold stone rooms,
The open mouths
Of Xerxes tombs
And the ruins of Persepolis.
I was a camera then.

When I returned to school again, Persia
Still hung inside me like a lantern,
Swinging as I walked, my new eyes
Polished bright from inside,
School and children transitory
In the shadow of such
Ancient, bloodied, golden history.

THIRTEENTH YEAR 1972

Being stationary, fortnightly, at boarding school,
Allowed the opportunity for apprehension
To take on shape and grow a face.
Mine had a name, a disciple,
And a punch in the arm
Like the kick of a mule.

Each weekend home exploded
In my head with the longing for it,
I would fill the idea like a cup
Which overspilled, and exchange it
For a bucket. Every other Sunday night
I'd carry it back to school, rattling,
Sometimes with bits of beach, or Dartmoor,
My father's fishing lures
All tangled up in the occasional
Weekend friend and piles and piles
Of washing up, clattering.

And what would I become?
Too tall, I tried to dance,
My legs like branches of a tree,
I tried to learn piano
With all ten thumbs
And undiagnosed dyslexia,

The notes no more than ink spillage
Despite the patient tutelage
Of my frustrated teacher.
But most of all I drew,
Too shy to be the one to speak
My pictures talked for me.

I was a teenager in waiting, bursting
To have platform shoes an inch high,
Beckoning adulthood as if it were
A smiling boy with eyes like cut-out sky.
Gauche and clumsy, dogged
By doubt and mousy hair
I found my home in books,
Where dreams were realised and looks
Were overlooked.

FOURTEENTH YEAR 1973

Four willows rose from the dirt, tall
And squared, trailing green
By the churchyard wall.
There I built a treehouse
The year I was thirteen. Torn down in minutes
In a boy's laugh for a woman's line of vision.
Badger Bess scrabbled tunnels in the cob of her stable
To gouge bulbs from the flowerbeds. I'd cut up
Raw liver and lungs for her, but most
She wanted marzipan. At school
I tied up loose ends
With bullies and friends
Before leaving at last,
When early bed as the holidays began
Made nights long as a noose.

On the day of my first necessary bra
Bought with the woman wearing the mother-suit
I carried in my head, my joy
Was to be with her alone,
Companions for the purchase.
Incautiously, I loved her
Right down to the mother-need
That was the hole in my heel
Where the poison would enter.

I believed I'd chosen right
And that she cared for me,
But she severed me from her side that night
With words like blades of steel,
Spoken to separate. She thought me too familiar
She said, smiling over spaghetti sauce
In the frying pan.
She asked that I keep my distance,
Adult and wise as she was
To the child I was then, since one day
I'd probably turn on her and say
"You're not my mother," in a moment when
She was exercising her unquestionable
Authority again.
The firm ground in which I'd dared
To grow roots, was turned over and bared
To the elements.

My new school had no weekends off,
Friends at home grew bored and strayed
Or simply moved away.
Determined to excel I settled in,
But would I ever thicken
This too-thin skin
So not to feel the spike

In every verbal slight?
Self-consciousness was quickening.

In the holidays I'd try to write, always interrupted
By heaps of washing up, even my diary says
"There were humungous piles of it."
It became the pivot
Of everything I did,
Filling my head with scouring pads,
Cups, plates, saucepans, cutlery,
Casserole dishes and washing-up liquid,
And every morning I'd be woken
To make that first cup of tea
While my brother slept on,
My name a chain
That would not release me.

FIFTEENTH YEAR 1974

I was bursting at my seams.
No matter how I stood,
Folded or unfolded, I could not
Lessen the impression
Of my overstuffed skin.
I was exhausted
At the daily weight of wearing it,
I wanted to climb right up out of myself
And fly off like dandelion fluff.

An item in the news
Released my mother's story,
Her suicide a secret
Kept from me 'til now,
My stepmother explained
Before the revelation caught me.

I was silent at the sudden loss again
When a friend had kept the article for me,
In it I could clearly see
That there I was, born my mother's daughter,
It put an end to my belief
I was adopted. I'd kept my secret,
Now I hid relief.

I dragged my large and fleshy shell
Through Cape Cod and Wellesley
On a visit to my U.S. family,
Hoping it would wear off
Like some bad smell,
But my curvy rounds clung on to me
Like stubborn lovers.
I dangled awkwardly between
A child, in bed at night in broad daylight,
And a teen, almost old enough
To marry, vote, and drive.
I felt to be waiting,
Biding my time in my chrysalis
As the days passed by and I became
Something else....

Meantime, I knew my size was sin
And thought I'd be much prettier if thin,
So dieted to slim, my fat removal
A vain attempt to gain approval
From the mother I boasted of
To all my friends. I sang her praises daily,
Our relationship, I said,

Was close and loving, as troublesome to her
As my brother and I must have been,
Half grown as we were
And not her own. I believed
That if only I could find a way
Not to anger or repel her,
She'd love me in real life
As she loved me in my head.

But I couldn't find the language
That would undo our distance
Or cut through the seeming animosity
That grew towards me. The more
I laboured to be loved
The bigger the divide.
I'd harboured the illusion
That a mother loved so strongly
Would love me like a mother
So I'd be open and confide,
Wrongly, wrongly, wrongly.

SIXTEENTH YEAR 1975

As if I had suddenly developed
Some secret smell
Men began to notice me,
But I wasn't ready yet.
I hadn't learned how to handle
The size of my breasts,
Nor did I want to think
It was all they were after. Surely
They could see my brain
Gleaming with eager opinion?

Razor blades that shaved legs
Developed a double purpose
In a bath of quandary.
Would a bucket of blood
Open a woman's eyes?
Death leaves nothing but vacancies,
So I thought better of it.

A borrowed grandfather was buried now,
His funeral forbidden me, the outsider
In my stepfamily.
I was determined to ignore
Rejection of affection from
My chosen mother, but

I harboured hope, a weakness
That as good as strangled me
In useless, knotting rope.

I tried to hide
The shorn and ragged sides
Of my pale moon after
My first visit to a hairdresser
Proved a disaster,
But the damage was all
On the top of my head,
And daily visible
For a whole year to come.

My father pointed at a mirror
Where my face pooled back at me,
And told me I was beautiful.
Blinded by paternity
Made him the fool.
But I stared into myself and knew
I could make myself worthwhile beneath
This plain and fleshy sheath,
Every necessary thing could be put in
To the box of me, the sum
Of all I wanted to become.

I made myself a set of rules
And stuck to them, I hoped
To polish like a jewel.

SEVENTEENTH YEAR 1976

Three things occupied my mind,
Men, poetry and vomiting.
I wanted the blue leather jacketed
Man on a motorbike, fastest,
Most dangerous, making him
Most attractive. And he
Fell in love with me.
I'd seen him in the spring
And known instantly we'd marry,
And that he wasn't the one
In my mind's eye,
But that man might be
As far off as my eighties.
We'd wait, we knew,
With me at school.
Meanwhile, cigarettes became good friends,
I'd walk long ways to out of bounds
To sit and smoke, write poetry, and think.
Still trying to get thin
I'd stick my fingers down my throat
At every snack or meal, recovery
A state of mind I'd not condone
Until I finally reduced myself
To skin and bone. My chosen mother, then,
Would think me beautiful,
And as she was in control

Of every aspect of my life,
This one thing I controlled.

In my dorm at night
With no one there at all
I'd take my dagger from the drawer
And practise throwing
Into the flower-papered wall.

During holidays I'd shop
For my deteriorating grandfather
Who'd not
Recognised me for some time.
I'd sit with him as he watched
His paper hankies drying
On the plastic logs that lay
In his electric fireplace. It was as if
The room was empty, he no longer
Recognised my face
Or heard the things I said.
I was just a passing figment
On the periphery of shadows
Of all the World War dead,
That were more real than I was
And still inhabited his head.

EIGHTEENTH YEAR 1977

Turkey's pearly throne glittered
In the Topkapi Palace,
My aunt on a carpet mission
And me, fascinated by
Jellyfish swarms in the Bosphorous and Vehbi,
Who stroked and stroked my hair
As if my head were a cat.

Dental roots were dug out like plants
When three teeth died
As my body slimmed,
And I'd hardly manage stairs.
Sent home from school it was easy
To pretend I was mending,
No one checked my inner self
Still fat beneath the thin.

In holidays my biker friends
Became my family,
I'd brothers now, watching over me,
And in my boot, a knife. No one
Was going to slice my face
Like the girl who smiled at me double,
Her lips and her scar in tandem,
Her jaw cut open by a jealous friend
Who sat beside her, laughing, even as

She explained the reason was a man.
And when my aim was tested
My sudden accuracy quietened
Both the clamouring doubt in my head,
And my critic, whose respectful silence spread
Faster than his shout. No one touched me then.

At school I worked hard
To get my essays done by Tuesday,
Which gave me time
To write more poetry. I got engaged,
It seemed a good idea to make the choice
Between two very different boys.
Afraid of floundering I hoped
To give myself a base, somehow,
To paint and write I'd need a life outside,
Better start it now.

NINETEENTH YEAR 1978

My birthday year's begun
With sun and boyfriend's love,
And anxiety at where I'd be
When school was done;
At home the space I'd taken as my own
Was closing over, as if preparing
To expel me like a spat pip
From the safety of my room.

Crushed in a car hit head on at seventy,
I was cradled by two firemen
Who cut me from the wreckage
Of the back seat with a power saw,
Pulling me from the roof of a vehicle
That had ceased to possess
Any shape at all. For endless weeks
My friends were legs between lessons
When all I could do was swing
My useless pendulums. I practised walking
From school to town and back again
Across the fields, oblivious then
Of my fledgling biker guardians.

My English teacher told me
That other work might add
A few marks to my grades,

He tells me now
That he still remembers how
The ninety-six poems I gave him to read
Were terribly sad.

To paint and write I waitressed,
Until I found farm work and cottage
For my husband-to-be
In which we could live
And one day be married.
Kettle from uncle, iron from father,
Candy-stripe sheets from the back
Of my stepmother's cupboard,
A fifty-pence horsehair bed from an auction, and
A chest of drawers from my childhood bedroom
Furnished our torn linoleum and yellow walls.
Friends brought a sofa and chair
From the rubbish tip, thin cushions on springs,
The gaps between which
Our buttocks would slip.
Out of work I took
Every hour I could get on the potato picker
And bought a typewriter.
Mad, the boyfriend said, not knowing
How I imagined I'd write us out of poverty.

He ploughed the garden, I planted,
Weeded, grew marrows, carrots, peas and swedes,
I could make a meal from stock feed
Stolen from the fields, and would bake—
If we'd had more than
A one-ring cooker and two saucepans.

February found me work,
Collector of Taxes, Exeter B.
I laboured at my desk, back to the door,
Head down for mushy peas and flour,
Our lives plotted by the ha'penny,
Beans worked for by the hour
And clothes from the charity shop.
In the winter cold my skin split
From hand-washing sheets and cow-shit overalls
And the one blue pleated skirt I worked in;
A bloody grin between each fingertip.
Painting and writing—just out of reach
In time and materials—defined
The image of the future me
I strove to be.

TWENTIETH YEAR 1979

A motorbike at last,
The last one crashed a year ago,
Gave me a ride
Instead of walking seven miles to work
And back. My father took me
To a Royal garden party;
My last outing as a single woman, to see
The guests in all their finery,
Hoping to shake hands with royalty. I wore
A whole week's food on my head
In white lace. September saw me married
And milking cows at three a.m.
Through frozen winter weekends,
Keeping chickens fed to eat
In the absence of any other meat.
But I had a title now,
A "Mrs" brought respect.
I'd Hire Purchase on the cooker and
A fridge at last, my plan
To paint and write on hold
While I paid off the motorbike.

For summer I had a second-hand dress,
And in winter I wore it with a sweater
And petticoat.
A farmer and his wife moved in next door

When their house burned down.
She and I made friends,
Our husbands unequal, farmer and worker,
Not speaking. But our empty wardrobes,
Impoverished cupboards and chauvinistic men
Bound us together. Her nothing
Matched mine.

My driving test was passed at last,
And set me loose in the old escort van
My parents bought me second-hand.
With wheels of my own my world
Could rapidly expand.

TWENTY-FIRST YEAR 1980

Tax accounting at the office,
Hundreds, thousands, millions, my fingers fast,
Catching themselves up and overtaking,
The adding machine burning its digits into me,
My tendons jamming in their fleshy sheaths,
Crippled into plaster.
My days were divided
Into flexi-hours and minutes, my food
Was divided into portions measured out
Into infinity. My second-hand twin tub
Gagged on my husband's
Dung-encrusted overalls,
And convalescing hedgehogs spilled their bowls
Of jet-propelled maggots at night,
I'd shovel them up and toss them
Into the fire, their bodies
Popping like corn, spattering the carpet scrap
And torn linoleum.

My grandfather's death entered my head
Like a missile. I knew
The exact moment of his passing. I drove
Twenty minutes. Twenty minutes too late
Said my stepaunt at the door of her nursing home,
Slamming it sharply. I knocked again,
And her husband now let me in,

41

Her averted features contorted
By some deep and inexplicable animosity.
I sat beside my grandfather's husk, his head
A still carving of himself.
A long time now he'd not remembered
Who I was. I didn't weep to see him dead,
His body, empty of spirit, wasn't him, his skin
Was just the thing that held
His lifeless organs in.

Relatives gathered round his funeral
As if it were fire, warming each other.
My days, like abacus beads,
Arrayed themselves obediently,
And at last I was promoted
To the M.O.D.

TWENTY-SECOND YEAR 1981

The Triumph Bonneville motorbike
Was mostly parked up
Under repair in the living room
Of my first real home,
Bought by my father's care
Of my mother's written words.
Until my husband found a job
To release him from the herd of cows
That kept us caught up
At the old address all summer,
I painted walls at weekends,
Tiled the kitchen and scrubbed the floors
To make the cottage ours.

My one-time biker guardian
In leather and chains, who visited,
Bought the black veil pillbox hat I wore
To the funeral of
Another dead biker, and helped me
Bake cakes under the astonished scrutiny
Of my husband, who never availed himself
Of a single household chore in case
It castrate him. My days doubled up
Between leathers and boot-knife
And the Infantry Manning and Records Office;
The end of life in Northern Ireland

Coming through in memorial boxes.
I was crossing soldiers off
For rape, or spitting, or dying.
My new skirts and sweaters
Were smart acrylic at six pounds a pairing,
I was constantly flammable
In a different colour
For each working day of the week.

Nights home
The blows of words, filled out and leaden
Like little coshes, waited in ambush,
In threats, or hidden in smiles.
I was going to paint and write one day,
But first escape.
I searched for an exit,
Applying for jobs I found one to take me,
Sales manageress
Of a greeting card company.

TWENTY-THIRD YEAR 1982

Life began again, me as salesman,
Selling greeting cards,
My briefcase crawling
With snakes and lizards, shellac
Shaping them in black, I was painting
In my coffee breaks and lunchtimes
For their coloured jewels to shine.

I drove against the backdrop of the Falklands;
Soldiers going to war in summertime,
Their wives weeping on radio kept my eyes open
In the miles between Devon and Cornwall,
Card shop and card shop.

I sewed every hole in my husband's clothes
For his move back to his mother;
I could no longer face my nightly fear
Of going home to his suppressed fury.
But his frequent visits tormented me,
And his refusal to give me his house key.
Once he brought flowers, once the gun,
Shooting a hole in the dark in his fury
At my refusal to let him in
And perhaps turn it on me.
When his threats of violence
Manifested one night, I sought sanctuary

In the one place I knew that I'd be safe,
Only to be told to keep away
By the figure with the mother-face,
In case a stray bullet
Hit a neighbour. Neither must I
Disturb my sleeping father
Who would have moved me in
Against her hidden wishes.
I had not the strength then,
To be so unwelcome and stay
In order to reach him. If she saw
The livid bruises
That escaped the scarf at my neck
She did not mention them.

Three locksmiths refused to call again
When my husband tapped the telephone
And warned them off.
Months later, with a concerned smile, he said
My new lover was as rotten as bad meat
At the bin's bottom. His truth
Rang hollow in the separation
That now divided me from his daily anger
At my head full of independence.
But my business plan became a funnel
Straight into the new man's business arms,

His blacklisted insurance sales history
Making a proxy of me,
And I'd no idea he'd fuck a friend
And make her my enemy.

By March I was divorced,
But brief elation bottomed out
On the unease that permeated
My new relationship.
There were cheques amiss, and money slipped
Between excuses into this new man's abyss.
I'd stepped into a world where nothing was
Where it should have been,
Though he'd deny it endlessly.

And there were we,
Camping out in a rented room
While my ex-husband stalked my home,
And the boyfriend's ex-wife gave birth
To a child he said was not his own.
It was only later that I found
The boy had his face on,
It was just another lie
That he polished 'til it shone.

TWENTY-FOURTH YEAR 1983

I was digging mud and moving stones on weekends,
Measuring myself out on a task in the garden
That I could not complete;
It would grow over, more lumpen than ever
The moment my back was turned.

The business-partner-boyfriend
Promised cheques, mostly fictitious,
We lived on those promises
And spun a real mirage
Of future success out of our conclusions.
Blacklisted, he couldn't get an account
Without my name on it, I learned
About pensions and savings,
And futures from men in tall buildings,
My suit as dapper grey-woollen
As their faces, their eyes
On the nipple
Of my stocking fasteners
Through the fabric of my skirt.

I learned mortgages and MIRAS,
Futures reeled by me, their paper hearts ticking,
Cram it in, cram it in, knowledge and learning,
Fix it to the rafters of the head,
And all the while the boyfriend's idle feet

Beneath the desk in an office
I'd borrowed for, the secretary
Unable to type. He squeaked like a hinge
When I fired her for leaving
My letters undone and heaped,
While flanked by two admirers in the foyer
She knitted.

My overstuffed head was gagging at the seams,
I blacked-out frequently, oblivion
As sudden as a switch. Each time,
The last sound I heard
Was the dull thud of my skull
Like the slam of a door
As my head hit the floor.

TWENTY-FIFTH YEAR 1984

I'd learned more about money
In six months. Meantime, partner, mine,
Unscrewing minds to see his
As the carrier of hope. I closed our office down
To plug the money hole that his inability to keep it
Had dug in the floorboards, stripped up the carpet
And turn a blind eye to his infidelities,
He was palling on me.
I sent myself to college
On the back of the sale of a children's book,
And gave up writing poetry;
The parental comparisons
Would be too painful for me.

His lies piled up
On lies and lies and he, keeping taut
The necklace string of all his lying beads.
Door knocks opened to reveal
One debt collector after another;
My world narrowed to a tunnel,
End-blocked and filling
With the man's sewerage.
He'd been stealing, his name
A mantra on the lips
Of the disenfranchised. The telephone
Became a thing of terror, I climbed

Deeper and deeper into the safety of myself
Until I could no longer tell
What was acceptable, or good, or bad, or hell.
His frequent drunken vomit in the bathroom
Repelled me, but no less
Than his denial of it.
The purgatory smell remained
Despite my attempts
To erase the evidence,
My mind, he said, was all too colourful.

For three months I slept
Foetal on the spare-room floor
Without mattress or blankets, in between
Compulsively painting and writing and hoping
That in my hopelessness I might restore
Some sense of balance.

When my father made Poet Laureate,
The boyfriend ate six months' pay
In a meal as my father's guest. I told him to go
And he left when I wasn't looking,
Collecting his fifteen stone mistress
On his way out of the village,
Giving her boyfriend
All my best bed linen. For two weeks

I burned the six inches of discarded papers
He'd strewn across my living room,
Searching for my fallen pieces, finding evidence
He'd forged my name and abused my identity
Over and over again, and the debris
Of all the other people the bastard cheated,
Their lives as bleak and confounded
As Exmoor, but at their end,
When all hope of making up the deficit
Was gone. I was the lucky one,
Although I'd lost my home
And almost everything I owned
I was young enough to start again,
If only I could recover from
The shock of betrayal that hit me
With the force of a swinging wall.
My father came and sat and listened then,
Not showing a single bone of judgement
When others did, but simply understanding
As I wept and wept and wept.

TWENTY-SIXTH YEAR 1985

I was finishing an art foundation, drawing faces huge,
So they gazed from the wall in their two-foot tall
Terracottas and blacks, for my end-of-year,
And I pushed weights until
My shoulders could almost
Walk on their own. I swam
With air force friends from Chivenor,
My country life about to end,
Precarious for food and electricity,
Each shilling measured out
For petrol, or a single pair of shoes.

The husband who had once
Hounded me to misery
Introduced his new wife,
Took us for a drink
And became a friend again.
The con-man boyfriend
Who had dismembered all aspects of my life
Was jailed for fraud—though not of mine—
I couldn't relive that in court
And go through it all
A second time,
And Central St Martin's gave me a place
At the end of my art course in Devon,
Though London was the heaving mass

I'd wanted to avoid, the millions of people
Crawling over and around each other,
Refusing to admit they were too many.

In Portugal with friends I noticed
The odd man out, on a BMW motorbike,
His exhaust pipes shining
Among the tourists in their caravans,
My Dutchman, a shipboard engineer.
A holiday romance, they said,
But he followed me to England and back again,
He sailed me round the coast of Africa,
Frieda on a freighter, an engagement ring glittering,
On time borrowed from college, sketching,
Drawing cartoons of my ship-board family,
Photographing Morocco, Ghana and Gabon,
And finding sea legs are only won
After three days of bilious green.

I was brought to my knees by the rolling sea
As the boat pitched from side to side
At forty-five degrees, the gradient so steep
That stairs were either horizontal or vertical.
I lay starfish on the bed in order to keep
From being tossed into a corner and heaped.
Once I'd learned to navigate

The fluctuating gradient
Of the surface beneath me,
I'd dangle my legs at the ship's edge
And watch the dolphins and flying fish
Thread the wake as it melted
Back into the sea.

TWENTY-SEVENTH YEAR 1986

My twenty-sixth birthday on the freighter
Was celebrated by officers and sailors
In their second language, I was
Seeing the world from the sea.
My foot ripped open on rusted metal in Angola
After a supply-boat party thrown for me
And a man from Exxon,
With Robert Mitchum's face on.
I'd stay up late, kept awake
By the pounding of Vesuvius beneath my skin
As the wound formed a mountain range,
And watch the oilrigs, their match-stacks flaming,
Out on the far-off edge of the soot-black
Watery plate of the earth, UNITA
Only twenty-five kilometres away,
And everyone ready to evacuate.

I left the boat in Brazil,
Where a cab driver hid me
On the floor of his car
On the way to the airport,
Lest he be ambushed at a red light
For his passenger,
Pointing out the colossal viaduct
That was the proud spine at the crest
Of the forests of trees

The people did not care about,
And prostitutes fought for attention
From the rich Dutch sailors,
Their poverty disguised by smiles,
And colourful clothes and careful nails,
And their kindness to me
As we danced together.

But I realised that as a sailor's wife
My home would either be a suitcase
Or an empty house and solitary life. I returned
To my tiny room in a Bromley flat,
My car crapped on by every bird in London
And mould on crockery,
Three months in the sink; the other tenants'
Breakfast things from the day I'd gone.

Hunting for another home
With yet another loan, I met
The estate agent I knew in an instant
Was next, whether I liked it or not,
Though he still wasn't "the one."
He bid at auction for me,
And moved in when my flat was done,
And I'd scraped the walls
Of sixty years

Of a dead old woman's history
In stripes and roses.
Two lodgers subsidised my income
And diagnosed dyslexia gave me the reason for
The thought process that had hobbled me
For all these years;
Knowing set me free.
Meanwhile, I systematically
Embraced each art school project,
Returning home each night
To tentative security, and the belief
This lack of progress
Was only transitory.

TWENTY-EIGHTH YEAR 1987

At college I finished
Almost everything asked of me,
And refined my flat continually,
Making its humble parts pretty,
At last replacing the dinner plates
I'd bought second-hand at eighteen,
And the camping cutlery.

Various lodgers continued to bring
Their habits and boyfriends
To my two spare rooms,
While I sculpted Shakespeare's people,
Their hands and faces drying separately
As if they had been momentarily
Put down by their owners
And forgotten. Plaster powdered everything
From floor to ceiling, and congealed on sheets
That covered furniture. My white
Powder footprints followed me
Up and down the corridor, my skin,
Crabbed and mottled with drying,
Grew coarse. My partner revolved
Like a wheel rim around
The pivot of my life
And his long-ago ex-wife. I ran his office
In between my college hours

And hypoglycaemic black-outs,
Working both ends of a day without pay
For the first three months, and thinking
Of the spectacular art exhibition I'd have
If only I could find a gallery
To take me on. At night
I painted fish scales and feathers,
Imagining a coastline of mountains and beaches
Beyond the water I was treading,
Where the nearest ground
Appeared to be three miles down.

TWENTY-NINTH YEAR 1988

Love persuaded me to work long hours
In my lover's office as my
Final college year passed by.
From office, to college, to office
My days were long and tired,
I should have walked and let him be
But lacked the stamina required.
I believed his eighteen extra years
Brought wisdom, and was most attracted by
His consideration for me,
So found it hard to understand
When he favoured daily business lunches
And weekend football on TV.

I emerged from college
As a self-employed
Artist-writer-part-time-estate-agent
Of doubtful income and uncertain future.
I'd loved enough to marry,
But now, as put aside as I was,
So was it. I felt myself
Rolling forwards like a stone
As the plane of the Earth tipped.
My parents' Christmas gift
Was a trip to Australia to see a college friend
And relatives. And there, on a train

Across the Nullarbor Plain
I fell in love with the outback
And an Australian.

Tracked down to my uncle's in Melbourne
I spent Christmas with a partner
Whose grip on me grew tighter
Now he felt me slipping;
As faithful as I was 'til then,
My mind was travelling.

Once back in London
Among the thrashing bodies,
The city seemed to be
The whole country. I wanted
The noise to recede
As it had in the outback,
And allow me to breathe. Inhabiting
A narrow world that spanned
Only the thin black Northern Line,
It was only a matter of time
Before I crumpled like tin.

THIRTIETH YEAR 1989

Craving red dirt and kookaburras
I was homesick for Australia.
While a mile-long meal that had been dismissed
By a college tutor's careless hand, became
A book in America, Australia and England,
My terracotta walls
Were closing in on me, my husband-to-be
Not understanding how football on TV
In the corner of the living room
Made my work a mockery, and me,
Responsible for where we lived,
The gas and electricity. I'd sit
At my draughtsman's easel, staring from the window,
Longing for some happening
To set me free. A painting sold,
My beginnings like small shoots.
But all the while the days
Became more and more the same.
One day followed the other, like an echo.
I wrote and painted, slept and ate,
Swimming in a bowl the sides of which
I could not negotiate. Driven by his loss
When I escaped to Australia again,
My lover begged me to marry him
At last, at last, at last.
Too late.

Not wanting to say "yes" but fearing
"No" might send him off the edge
I fell too low to fight,
So made a bargain that I knew
He could not meet, and he agreed,
But covered up the break in it
Until it was too late for me,
As if the tickets to Gambia and registrar
Were less changeable than marriage.
And when I answered "yes," I lied,
But couldn't spear him with the negative.
I'd been buried too long inside
To withdraw my sacrifice. Weak fool,
My face in wedding photographs
Is at my funeral. My spiral
Was gripped in both hands
And down I plummeted,
Daylight escaping daily.
I was younger when
I was here before,
And the dark looked different then,
Whereas now the pit into which I fell
Drilled right down through the floor
As far as Australia.

THIRTY-FIRST YEAR 1990

Waldorf and the Sleeping Granny
Saved each other, but my children's novel
Couldn't save me. My days were identical.
I always believed that this brought comfort;
No surprises, no upsets, no questions, just
A slow pace from one end of the day
To the other. My sky was grey, my landscape
Flatter than Norfolk, my mood
A numb and heavy thing. Sometimes
I'd move my body sluggishly
—Like luggage—
To the kitchen for a cup of tea
And forget halfway,
So sit, and stay, and stay,
And maybe sleep. By dusk
I'd wake and work
'Til three or four a.m. my husband
Physically as far from me in mind
As another species altogether.

By September, each foot
Was welded to the floor
The moment I placed it. It took
An hour to walk fifteen houses.
My doctor questioned me, my life so perfect
There was nothing I could see

That put the surface of the earth
At the level of my knees.
I refused her pills. I was depressed,
She said, but wanted to find my own way
To raise my head from the table.
I wrote myself down.

My father learned me through
Seventy-four pages of the highlights
Of my history, and his shingle blisters.
I'd figured out my roots
And needed him to see
The real soil that grew me.
He'd been uninformed 'til then,
Sound and vision both impaired
By my stepmother's translation
Of all the thoughts I'd shared.

In my whole history with her
I'd blamed myself for being less
Than she could love,
It was only now I realised
I had nothing to be guilty of,
And accepted that not loving me
Was not a crime;
It was just the way she was.

My mind, set free of puzzlement,
Released other secrets too;
The memory of the moment
I'd lost it as a child
Returned to me, completing history
With pictures of my grandmother
Reducing my mother to misery,
Threatening to steal us while
My father's back was turned,
And take us overseas.

Another book accepted
Was no joy to me,
I lived daily in yesterday
Which was also tomorrow
And every day after.
Even the cancerous beginnings
Of a cervical anomaly
In stage two, heading for three out of three
Couldn't shake me from oblivion.
It was just another
Stone in my road to step over
In my same old, same old world.
Tissue was cauterised without anaesthetic,
Because being this numb, what point?

Maybe now I'd feel something.
As consciousness lost itself I realised
The pain was three people away
And I was only fainting by proxy.

THIRTY-SECOND YEAR 1991

Our separation was as secret as our wedding had been.
Red dirt from the Australian desert stained me,
My passport languishing in the hands
Of the authorities, until November
When I was granted residency.
I was planning my escape, my husband's hope
The rope that constrained me,
My need to free myself so strong
I was dragging my burden,
Heading for Australia
And the arms of an Australian.

My sister-surrogate in California
Employed me to redesign her home
With architect, as if it were my own.
It was the means by which I cut
The stranglehold of Hessian
I dangled from. My husband
Became a lodger for free, and me,
Paying, paying, penalty
In spirit and mortgage and guilt,
Treading water still.

Australia was the golden plate
On which I rolled like an eager pea,
All green from rainy England,

And more in love with desert stones
And empty, open scenery, than you'd think
From my home in the suburbs where
Five weeks in six
I lived alone, painting.
And when my shoulder muscle tore
While making furniture, the sound
Like a wet shirt ripping,
The pain so sharp my right arm
Felt to be severed, dangling,
I learned to paint left-handed,
So the work that gave me shape
And imbued me with purpose
Would continue unabated.

New friends became my family,
Orphaned from the Eastern States
Or overseas, and for a while
I revelled in this new-found freedom,
My life so simple in
The hot Australian sun.
I pieced myself together from
The cadmium orange flowers of
The Australian Christmas tree,
The grevillea and river gum.

THIRTY-THIRD YEAR 1992

Summer in London, my ex-husband's lover
Had moved things in my home,
We were disentangled by divorce at last
But the place was still my own.
On a Devon visit I was faced
With an afternoon's persuasion
To change my name,
So never give an interview
And keep the secret safe. I refused,
Insisting I was born a Hughes.
My father, pointing out that this was true,
Said I should only do what I wanted to.
But the demand from someone
I thought close enough to know
The pain she'd cause, caused pain,
Not least because she'd married
The surname we both used.

Back in Australia again,
With the man as my spouse,
I bought a house, its tiny pool
Taking up the whole back yard.
My ageing face in the mirror
Cracked back at me, my cigarette skin
So bagged a thing I'd carry shopping in it,

It was fifteen years older than the rest of me
After eighty cigarettes a day.

Another children's book began the year,
But in order to exist
I found myself a second job
As magazine cartoonist,
And gave up smoking.
The immobile tongue,
The inability to clearly speak,
And the constant weeping
At the loss of such a friend
Took several weeks to pass.
Cigarettes
Had accompanied my breakfast, lunch and dinner,
My anorexic efforts to get thinner,
Good sex, bad sex, or any sex at all,
Walking, dancing, drinking,
Or simply thinking. Now
The empty space they'd filled
Was as wide as I could reach,
As tall as I could stand
And almost too heavy to carry.
With friends or without,
I was terminally lonely;

The void engulfed me.
But the prison of addiction
That had feigned friendship
Now so repelled me, I could not go backwards,
Lest my self-disgust at failing to escape it
Choke me completely.

THIRTY-FOURTH YEAR 1993

Painting, painting, a one-woman show the thing
I worked for. Fattening, head in the fridge
To avoid a smoke, I garnered the proportions
Of a well-fed porpoise, perched at the pool-edge
In between more paintings,
Until they were all done.
Back in England my September exhibition
Grew closer. My father typed
The name of every single friend he'd got,
And some he'd not, thinking
They should come.
I wrote each one and they
Turned up in droves, except for him.
He came before, quietly, to see
Everything, his face a lantern
In the light of all that colour, his grin
As good a thing to frame.

In England, the four months pregnant cyst
That buckled me, was left inside
As medical economy.
In Australia they took it out
By laparoscopy, and found the English missed
The real cause of my years of monthly misery,
Endometriosis.
Now I became a testing ground

For different kinds of pill
To alleviate the symptoms
That made me ill.

In January my sold paintings secured
An ugly prefab home
On the most beautiful bit of land
I'd ever seen,
With creek and eucalyptus trees.
Wooroloo took my breath away
As a lover does,
Its dry, sloping fields, its slow stream,
Its boggy bits at the boundary,
Brought stillness to my centre. That first
Intake of breath was continuous.
In the evenings
I'd sit on the veranda
To watch the sun drop into the horizon,
And the kangaroos settling
Up in the top field. Every night
The kookaburras and ring-necked parrots
Hacked the air into pieces between them,
Until their discordant exuberance
Was silenced by dark, and then, like a bright fog,
The stars crowded infinitely.

In February
My strength deserted me; my body
Crumpled beneath the weight
Of Chronic Fatigue. The weakness, the aching,
The physical difficulties in waking
Grew worse. My body became my jail.
My fury welled up inside me
And fell asleep.
Unconsciousness enveloped me completely
Like a black sack
That split open only for occasional
Glimpses of my surroundings,
Before exhaustion dragged me back,
Oblivion, my enemy.

THIRTY-FIFTH YEAR 1994

He, who'd set up home with me
Became gritted between
The two stones of my exhaustion
And our proximity, he had to leave
So I could be single-minded
About the small actions of a day
That were now mountainous.
I grasped my minutes
In semi-conscious fingers,
Fumbling for clarity, each thought
A marble rolled across the floorboards
And stopped in a knothole.
My unfinished ideas littered like spilt jewels,
Forever stuck in their hollows,
M.E. they said, no cure, just sleep,
Day or night,
Forever and ever if necessary.
If it were all in my head
I could have fought it, instead
It inhabited the whole of me
Like some comatose parasite.

All this in secret, and then,
Like a small raft
In the black sea I floundered in,
My stepmother arranged responsibility

For my mother's poetry
To pass to my brother and me,
With both benefit and cudgel.
But in order to move
I must persuade my brain
There was no question to answer,
No errand to run,
No commitment to fulfil.
My feet failed me.
Each day arrived;
Another mountain. Each day my tent
Was pitched nowhere near the summit.
My life was quiet. People
Drained me, as if their conversation
Punctured the bucket I swung in
So I'd leak into the hot sand and evaporate.

I spent eight months asleep,
And then my American friend
Flew me to the States
To see if recovery could be
Brought in by lack of daily worry,
In a moonscape of hot rock
Utah mountains.
My paintings were moments in passing.
I took each waking hour as

A thing for which I had
No expectations.
I asked nothing of it.
Poetry, stopped and bottled up a decade,
Poured out. I couldn't read it
But I wrote it down
As fast as my fingers could stumble
Between the two walls
Of sleep and sleep. Without my defences
It was set free.

I was going to find my way around mountains,
I'd burrow holes,
I'd trick myself into attaining
Small goals, each rebuilding a little more
Of the foundation of myself
That had powdered beneath the weight
Of too much expectancy.

THIRTY-SIXTH YEAR 1995

M.E. is the secret I hide
In my waking hours.
I feed it sleep in my quiet, I balance events
To match my small moments of energy.
I write a children's book
By placing words in rows
Like obedient children, hoping
They stand correctly. I can't read it.
Excitement at my first Sydney exhibition
Launched me straight into the gallery owner's
Locked doors, behind which
He drank my sales, and endometriosis
Bled me inwards, until a hysterectomy.
Full stop for any family. In Perth
I worked doggedly,
Sleeping at my canvases
Until I'd made them sing louder
Brighter, better than before,
For another show in England.
Like the most lovely children,
They found homes, the private view
The pinnacle of the mountain in my mind
I had to climb a second time.
But the last operation left me
Unable to eat, as if I was somehow
Separated internally. I knew

That if no one found the reason why
After all the painful tests that specialists devise,
Eventually I'd die.
I dared not share that fear
With anyone, so going to a party
Seemed a good idea,
Cementing my resolve
To be medically nonchalant.

Midnight, said the clock,
When, as Cinderella going backwards,
Skinny as hell and getting thinner,
I stepped onto the garden path.
The side gate swung open, and there,
All my knowledge of my life's mate
Met in a man's face. His gaze
Knew me immediately.
We stopped and stared, each riveted,
And in that blazing moment
In the dark, the silence in our heads
Like the clash of cymbals,
We knew we'd been prepared.

We moved in on our first date
Without surnames or history.
We'd marry, he said,

But I made him wait
Eight months. Two days after
He'd run his fingers over
My unscarred skin, my complete covering,
They found the colon twist that was starving me.
When they cut it out it was he
Who nursed my two separate halves as they knitted
The crotch to navel split.

THIRTY-SEVENTH YEAR 1996

László arrived in London beside me.
I had to teach him how
To walk through Londoners
Who'd trample him into the pavement
If he so much as stood aside
To allow an old lady by.

We painted, our canvases crushed
Into each other's edge
By the roof pitch
So we shared splashes.
Lloyds Bank put on a private view
For their favoured few, and we
Practised weekly for the show,
Boarding bars and hooking wire
Into all their oak, the desks to go.
A practise run at weekends
Sharpened us, we were learning each other,
Our hands on the map of ourselves,
Fighting, in love and at war,
Our identities struggling in disbelief
At the thief of ourselves
Who had stolen us,
Marriage, an absolute foregone conclusion
Where only denial had ever been before.

In Australia we renovated László's home
To set it up for sale, interrupted only by
Our December wedding
On the banks of a bird river
Full of black swans.
I'd met my match, *the one*,
My missing bit, my almost-twin, the man
Who would stand beside me
Come what may, and it did.

Western Australia blackened in a bushfire,
Animals were cooked into their fields,
My property blazed
And my trees and saplings were severed
At their burning knees, traced out in ash on ash.
The insurance assessor who was removed
For cheating on our claim,
Piled disbelief on disbelief;
Such a blatant thief in the midst
Of all that carnage. In the black of night
The stubs of trees glowed orange;
Disembodied markers scattered across
The thousands of acres of blackened ground
Where no animal remained,

No bird flew,
No insect made a sound.

For weeks I couldn't sleep. At László's house
I paced, painted flames
And wrote poems about the fire.
I landscaped his garden as if I could
Somehow put back all I'd grown and lost
On his little plot. Then
My brother phoned. My father
Now had cancer and
Impoverished as I was
I must find the fare to fly me back to England,
But couldn't get a loan.
As if providence heard, a friend
Brought a one-legged gold miner
To our studio, where he bought my painting
Of a one-legged bird, for enough
To get me to my father's bedside.
I knew then
It was time to move home again.

THIRTY-EIGHTH YEAR 1997

The Irish builder won the deal
To rebuild the incinerated Australian studio;
We were not to know
The uselessness of him in the hands
Of the useless designer, whose timidity
Left gaping holes in our walls
Where the windows should be,
And gaps downside doors
And leaning supports as drunk as he
Who placed them so arbitrarily.

In England, we made
A derelict home our own
And, having moved in London, three days
Into a house with water and power
Only on the top floor,
We had the thing we'd worked for;
A double Cork Street exhibition
In two galleries.
The replies to invitations
Deluged our efforts
Until the death of a princess
On the very day we hung, her funeral
The day we took our paintings down,
Our livelihood a pebble in
The vast scow of national grief.

We lived in one room in the attic
While the workmen took us on
Daily, until the top floor was done,
And Australia waited, unfinished,
So that plasterwork and joinery
Were what I dreamed of.

Christmas found us back on the edge
Of the bush, our crooked studio erected
By our crooked builder.
We fixed things constantly,
Exchanging London for Wooroloo,
Picking up the hammer's twin.
Fire came through again,
But we caught it this time,
Four fire trucks and beaters
Fought it back from the creek line.
Best of all I read a book
For the first time in three years
Since diagnosis of M.E.
The words no longer escaped,
Meaningless, gibbering senselessly,
But clearly spoke to me.

We were managing a team of men
In our London home,
My father sickening, even as
I began to wake again, reading
Birthday Letters and cluttering
Each empty room with storage furniture, so he
Could look upon
The blazing fire painting and the scarlet poppies
He wanted for the covers of his book,
His urgency not lost on me.

THIRTY-NINTH YEAR 1998

Wooroloo, first my home,
And now my first collection,
Sat in my father's lap, its jewel
Glittered in his eye of pride,
He was beside himself with joy.
My book of poetry
Now trapped me in its pillory
For everyone to see.
He saw it firmly between covers
Before he died, and the husband
Who'd care for me as he'd want him to.
He knew that all my other beginnings
Had purpose in preparing me
For endings.

Every waking day
Between building inspectors and bags of cement
My head was filled
With the presence of my father,
His voice on the telephone telling me
Over and over how he loved me
As if I must learn it, and
Might not have heard him the first, second,
Or third time.

My poetry was where I hid
When my father died. The crevasse in me
Opened up by my father's death
Just wouldn't close. Into it
Poured sympathy; bandages
Tossed into the bottomless well
Where I'd fallen, myself
Into the pit of myself,
My snake's tail eaten,
Inside out, bellied up,
The shriek in my bones
Like the sound of eternal bagpipes
Mourning, my limbs the sticks
That funnelled the scream of wind
From my father's funeral fire
Through their hollows.
Food sharpened and became nails, swallowed,
Remorseless spikes digging
Into Crohn's disease.
I couldn't escape myself, my grief
Followed me doglike from the inside.
But astonishingly
A mother rose from my father's ashes;
It seemed she saw me now,
Where before I'd not existed,

Her unexpected occasional kindness
Raised me from my knees.
Despite my husband's warning tone
I brought her home to me,
Whatever she offered of herself
I'd gladly own, I hoped
To be her daughter, finally.

Love, waiting an age
For small encouragement
Emboldened my phone calls of concern,
Until the eventual request
They cease. My sentiments, it seemed,
Were unreturned.
The illusion that I was not orphaned
Was broken by the word.

FORTIETH YEAR 1999

As if to practise me for public scrutiny
In the sharp, clear light of misery
My dead father won awards.
T. S. Eliot, South Bank, and Whitbread,
Each paid homage and I
Each time would rise to take
The things I wished he'd had alive.
His last book had set him free,
And he'd entrusted me
To the woman
Who meted out those parts
Of his legacy to me, as he
So carefully described
In his self-titled will,
As if it were the way
It was always going to be.
I'd got a mother now; the man was dead
And she'd buried jealousy,
Or had it been burned off in the furnace
That took my father's flesh
And made him bone?

When the memorial was over
And the photographers had gone,
My father's legacy was ended,
My phone calls unreturned,

I found myself orphaned from
The woman in whose promises
My father's wishes shone.
Dead now, he couldn't see
The skill and brilliance
With which she severed me
From what he'd wanted done.

Two days before my birthday
I received two envelopes. In one,
Her lawyer's message unstrung me
From all her letters promising
To honour my father's written words
In which he divided copyright,
And remembered family.
In the foul and broken sixteen months
Since my father died
She'd led me to believe
Otherwise, and I'd clung on this as truth,
Her assurances my evidence
That deep down inside her mother-core
She'd loved me more
Than I'd once thought.
But now it dawned on me
It was a game she played, and me
A trusting little pawn, betrayed.

In the other envelope she'd sent
A card for my fortieth birthday,
With love, both letters to arrive
Simultaneously.
She did not call me to explain
Or speak to me again,
Her telephone number changed.

I flailed, rootless, my husband
The one that caught me as I was abandoned
By the woman I'd wanted as mother,
Since I met her at the age of eight
And loved her.

And if I could see in her the pain
Of her father's loss so long ago,
Then how could she not see
The devastation left to me
By the loss of mine,
Made more crippling by my loss of her
A second time?

FORTY-FIRST YEAR 2000

My mother's journals are out now,
Complete; my father's last suggestion
For her legacy.
But I sleep whole days again,
Chronically Fatigued by the argument
Of relatives betrayed
When promises to keep my father's wishes
Were tossed aside, as we were.
Reason failed as lawyers did,
But after months of anguish
I'd not take that last legal chance
To end the matter since
The quality of life and freedom
Far outweighed the hope
Of any positive advance.

I'd write what's happened, but
The gawping stares, the gazes,
Unfettered then, would poke and pry,
So I disguised my truth in poetry
Of waxwork effigies.
But would anyone have pity on
A daughter's loss? They'd think it money,
Not stepmother cost,
Not the betrayal of a trust misplaced.
Daddy, Daddy, come and see

What she's done to me in your name
When the words you wrote
Were nothing like the same.
My year rotted me from the core,
I cried my father's loss
And ocean levels rose, their tide
Eroding cliffs of resolution.
I wasn't anymore alive
Then crawling took
Just to reach a time
When anger ended, leaving peace
And freedom—the cost already paid.

My birth mother's blue plaque
Brought me back from wherever
I'd lost myself, and I saw
No other mother could replace
The one that went before,
No woman would adopt
The child I was,
The girl whose mother's face
Unknowingly accused them
Of taking up her mother's place.
I'll paint my life in abstracts now,
These poems as the key
To the incidents that shaped me,

And celebrate my journey through
The thickets and hedges,
The maze of thorny edges
Thrown up by family and circumstance
From which I now am free.

FORTY-SECOND YEAR 2001

A second book of poetry was published,
Stonepicker, encompassing what I witnessed in others.
Slowly, I was creeping into the stanzas,
My imprint practising itself and wondering
If form and substance
Could be braver next time.
My pen at the ready, a third collection,
This time more personal,
Was evolving at my raw and bloodied core.
It tracked the vulture of betrayal,
My belief in other mother broken,
Joy smashed. The culture of deceit
Dumbfounded my efforts at clarity,
The Devil woke in me, see
The box my truth is in. Quiet, quiet, says
False mother from afar, through lawyers,
And what was to be yours
That you've not had
Might come in part, one day, sometime,
When I've taken what is mine
And seen if yours is left.
My father's words were read
But it seems that now he's dead
They're ash and grit, as he is.

Searching for a bigger space to paint in,
I met a woman living rat-like
In one room of a house that was waist high
In mail and newspapers,
And old banana peel,
Dating back to 1953.
Bent so double her nose
Rested on her knees, her clothes
And body had not seen water
In more than three years,
She could be smelt around corners.
Having vacancies in family
I took her on at weekends,
Sorting and clearing, washing
Her fetid clothes and cooking weekly,
So that she might eat something
More than a Mars bar.
I did not feel pity, but recognition;
If I magnified almost any aspect of myself
She could be me.

Meanwhile, a man who demanded residence
In our spare room,
Followed me around the inside
Of my own home, until one night

I was stalked to a standstill
In the dining room. He had to go.
The Twin Towers fell,
And all the people in them, I had never seen
Such carnage on a TV screen,
The images remain with me.

Truth, truth screams to be out and about,
And here come the effigies,
The mothers, fathers, brothers
Born of me; *Waxworks* in the making,
An allegory. Where I am dumb
They speak for me,
Swimming to resolution
As if it were an island, but
There's no land in this cold sea
Of loss, of lies, of maternal infidelity.

FORTY-THIRD YEAR 2002

Temptation offers contract for me to be one
With money coming in. And so I sign,
NESTA to be a governor of mine,
To make more of me than I can
On my own. Belief breeds effort.
My sleep-sickening remained
A hidden thing, for a step-mother
Ripped off the edge of me
As if hook-caught in passing, when really
She was simply escaping
At the earliest opportunity,
Still attached to my gullibility.

Waxwork effigies took on life
And walked and talked my poetry,
Each husband, each wife,
A suffering thing that brought its life
To bear the fruit of all
My father's death had left
In bitter hearts. *Waxworks*
Told my story, blow by blow,
The truth so bald my small advance
Paid for the lawyer's glance
Upon my facts: Leave nothing to conjecture
Where truth is evident
And proof abounds, he said. My waxworks

Now enacted history;
My father in his many guises,
And then the others, demons
Squabbling for their bitter prizes,
Their rendition of my story
Rescued me; loss of trust,
Withered of love, stuck again, motherless,
Grey, bloodied, waxy fission
Told the truth at last.

Now that I was free
From carrying the bag of knives
Of other people's lies,
The misery that ate holes
Into the flesh of my foot soles,
Leaking skin-fluid and blood into my shoes,
Began to recede. Where once I bled,
Now waxworks bleed.

FORTY-FOURTH YEAR 2003

Until a prince's mention
I had not known
That my father's memorial
—His Dartmoor stone—
Had been placed as he wanted, the ceremony
Forbidden to his family.
It was autumn before my father's friend
—Who picked the spot—
Lead László and me across the moor to see.
Already strangers had beaten a track
Through the grass to this nowhere
My father's marker lay, and me, his daughter,
A trespasser in the mind
Of the woman who had put him there.

In summer I broke from working on
My forty canvases
Of the abstract landscape of my narrative,
For winter in Melbourne
At a friend's side
As she tried to stay alive,
Her head a home for too many tumours.
We only left when we knew
She'd be here for a little longer.

Back in England, a plea was made
For my martyrdom
So better things could come,
But if I sacrificed components of
My history, the actual and factual
A treasure to me, when denial makes a jail,
A box, an airless tomb,
It is a smaller thing than I can live in.
I stepped aside and let it slide,
To hide myself
In painting images for sale outside
The landscape of my life,
A psychic mention having pointed out
The holes pulling in the fabric
Of all my constructions. Sleep was short
As László helped me keep
Momentum going 'til gallery walls
Were hung. Our paintings sold enough
To give us time to dress the house
For some new love. The suitors came,
The sale board flapping,
They gaped and poked and prodded
The grind and sod we made the place from
To be beautiful. Suddenly,

The house had chosen someone
And we must leave.

I felt happiness now
At where I came from,
All the pain of loss
And being cast off
By those I'd loved as family
Was gone. No more pretence
That all was ever well,
No more lies that implied love
Where none was felt,
No more corners and sharpened edges
Hidden in the false embraces
And stony eyes of those other faces.
The mother and father who loved me, died,
But still I carry them inside
And in my quiet, mourn for them.

FORTY-FIFTH YEAR 2004

Reined in from moving, from shifting,
From shedding the too tight skin
That we painted in, up for sale,
We waited until the deal was done.
Meantime, we'd see a gem,
Broken up and in need of polishing,
The walls a tad tight
But we'd rebuild later, only for
Some eager hand to snatch it.
At last we found "the one,"
So mired in dispute
That others passed it on.
Love, instantly. Expectant rooms
And hallways welcomed us, I was conscious
Of their bated breath and knew
Where each book, or rock, or lamp would fit,
And the places I would sit at dusk
To watch the sky pass overhead.

A kindly friend took on concern
For the old woman I'd cared for
At weekends, the self-confessed
Miserly pack rat I had grown to love
And feared leaving, in case she should die
After all my efforts to keep her alive.

There were ten trucks of everything
Over the two weeks it took to deliver us.
We hired skips—big enough to park two cars in
To junk the melamine
The vendors left behind,
And the house was occupied by fleas
That blistered my ankle skin
As I developed an allergy
To their persistent biting,
And wasps that swarmed and stung,
And five thousand flies that filled the landing
Outside our bedroom, but
The walls were full of promise.

My daily joy in waking was new to me,
And only briefly grounded
When my painting grant was something else
And taxable in retrospect
With three years compound interest.
We struggled then, with bills, but the hills
Were comforting, like green and earthy
Guardian whales. I was happy, still,
In our new home among the daffodils,
With László nailing ceilings up,

The electrician and plumber
Working through two summers,
The dust and mayhem
And silly pheasants running, and the rain
Just stunning against the backdrop
Of Lebanese cedar that towered into the sky.
Our work took on new life, as we did.

In the garden I dug up and shifted
Earth and rock, and sculpted shapes
In which I planted flowers, shrubs, and trees,
Cementing rockeries in labyrinths,
Occupying my mind in the moments where
I'd like to leave the painful thing behind.
Even recent history
Could not dampen my ardour
For this, our home,
A place for truth and clarity,
For peace and creativity
At last. Our sanctuary.

ACKNOWLEDGEMENTS

My huge thanks go to NESTA, National Endowment for Science, Technology and the Arts, in London, whose support during my project made it possible for me to write and paint something I only ever dreamed about.